kitty love

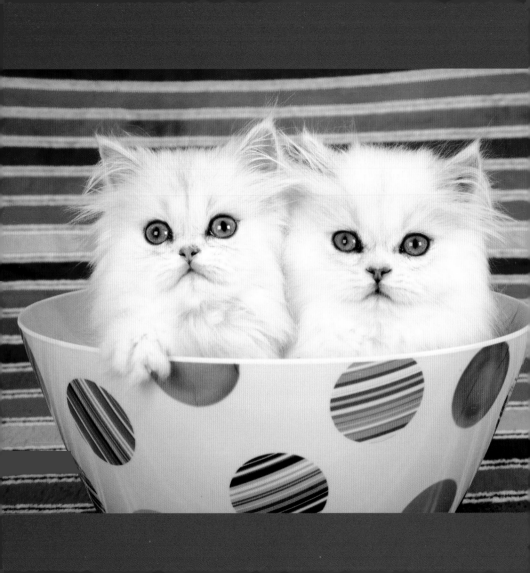

kitty love

how cute kittens play

STERLING
New York

STERLING
New York

An Imprint of Sterling Publishing
387 Park Avenue South
New York, NY 10016

ISBN 978-1-4549-1128-9

Distributed in Canada by Sterling Publishing
c/o Canadian Manda Group, 165 Dufferin Street
Toronto, Ontario, Canada M6K 3H6
Distributed in the United Kingdom by GMC Distribution Services
Castle Place, 166 High Street, Lewes, East Sussex, England BN7 1XU
Distributed in Australia by Capricorn Link (Australia) Pty. Ltd.
P.O. Box 704, Windsor, NSW 2756, Australia

For information about custom editions, special sales, and premium and corporate purchases, please
contact Sterling Special Sales at 800-805-5489 or specialsales@sterlingpublishing.com.

Manufactured in China

2 4 6 8 10 9 7 5 3 1

www.sterlingpublishing.com

"Come live with me and be my love,
And we will all the pleasures prove,
That valleys, groves, hills, and fields,
Woods, or steepy mountain yields."

—CHRISTOPHER MARLOWE

TIGGER AND PRECIOUS believe that beauty is in the eye of the beholder.

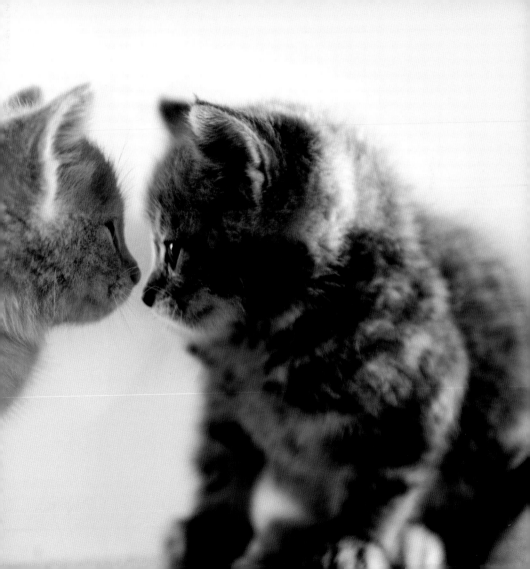

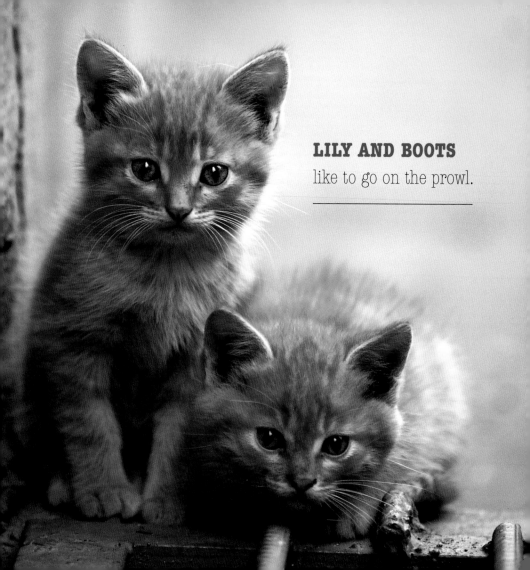

LILY AND BOOTS

like to go on the prowl.

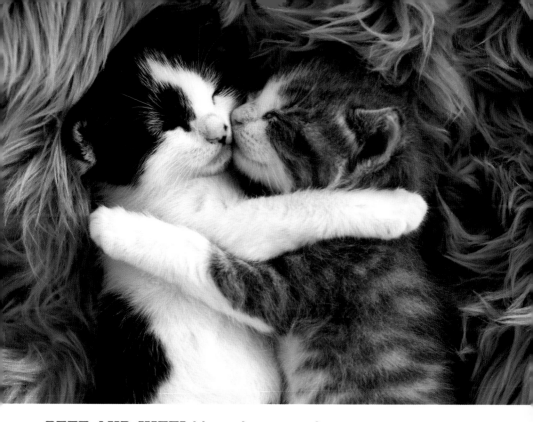

PETE AND KITTI like to hug on a shag rug.

GARFIELD gives **GILLY**

a giant bear hug.

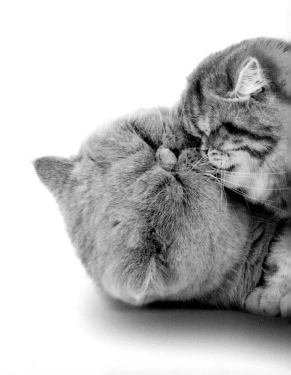

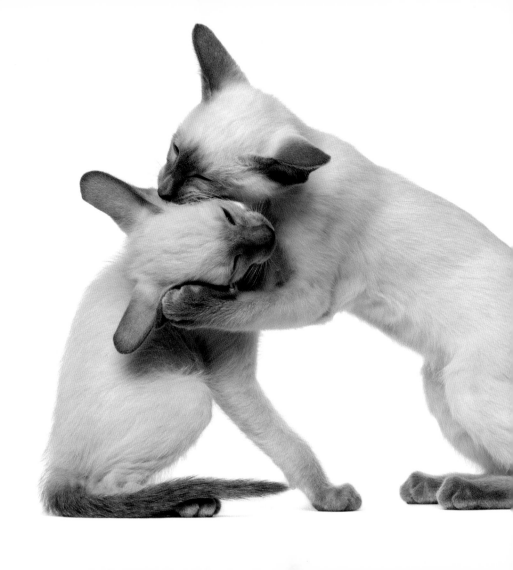

GOMEZ always loves it
when **CHLOE** speaks French.

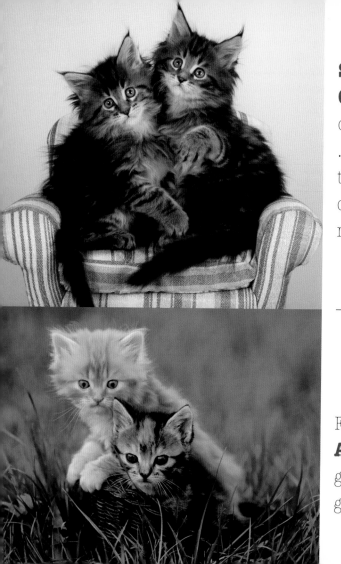

SHARON AND OZZIE are not couch potatoes . . . they just like to cuddle on the couch and watch romantic movies.

For **SOPHIE AND GIZMO** the grass does not grow any greener.

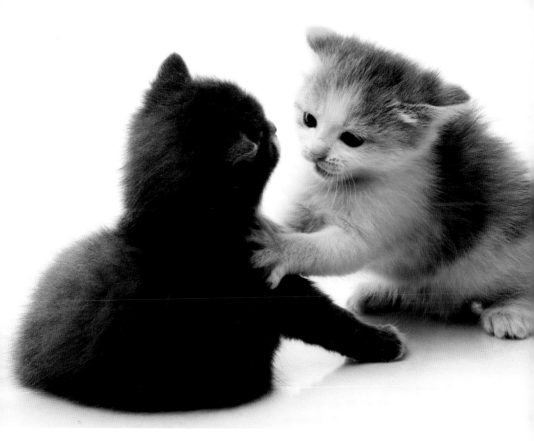

"Psst . . . I just found out where they keep the kitty treats."
SMUDGE AND FLUFFY like to share secrets.

LOKI AND KITKAT love to wrestle.

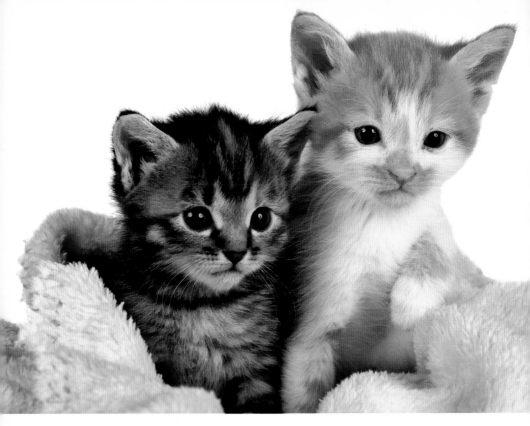

ABOVE: **JINX AND TINKERBELL** like candlelit baths.

RIGHT: **BRAD AND ANGIE** share pillow talk.

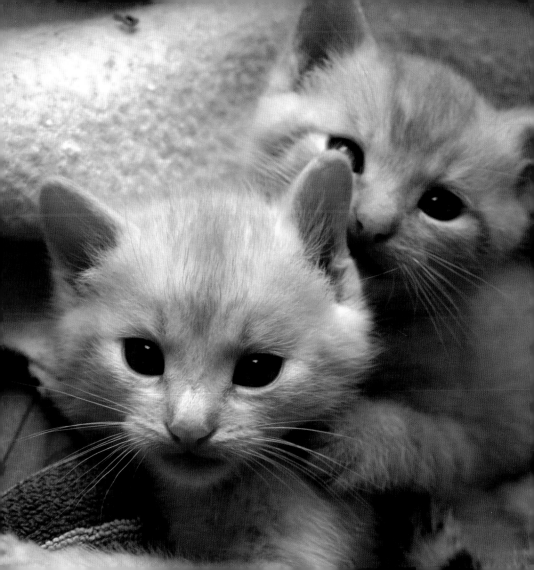

ZIGGY AND ZOEY catch a quick catnap.

ABOVE: **CODY AND GIGI** laze on a sunny afternoon.

LEFT: **MITTENS AND MILO** rendezvous by their special tree at dusk.

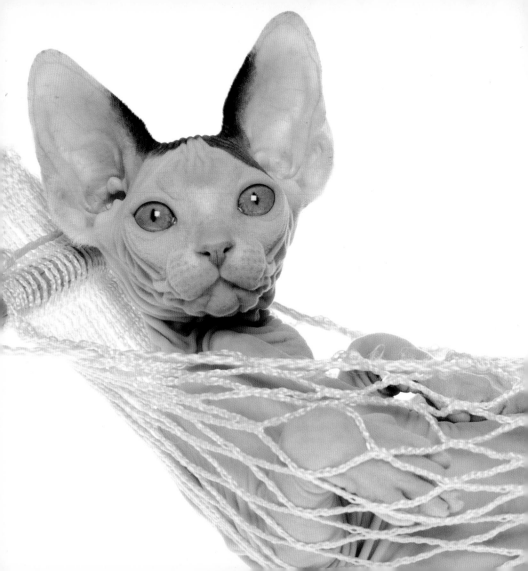

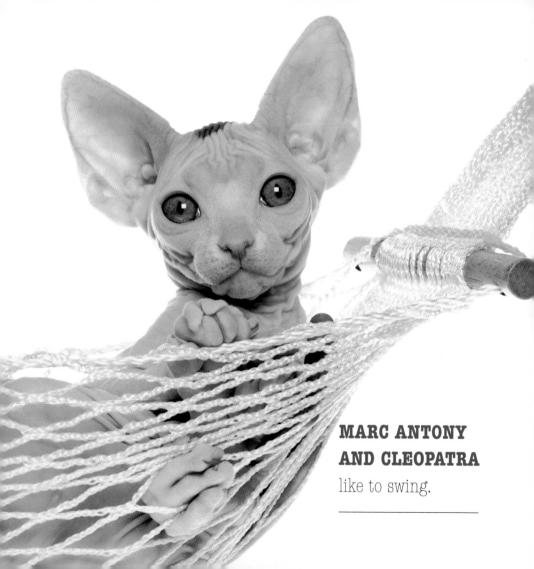

**MARC ANTONY
AND CLEOPATRA**

like to swing.

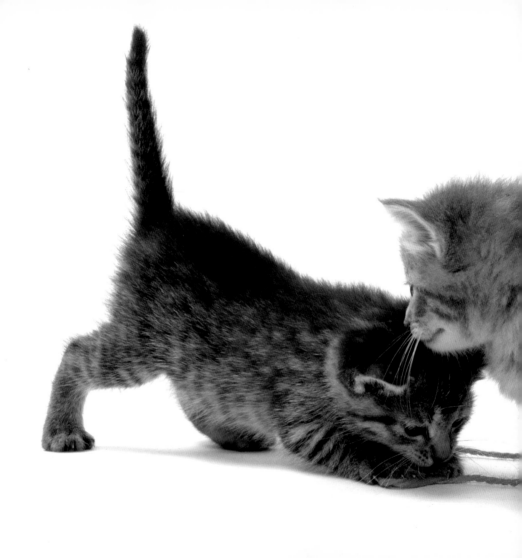

TIGER AND DAISY know that love is . . . sharing a ball of yarn.

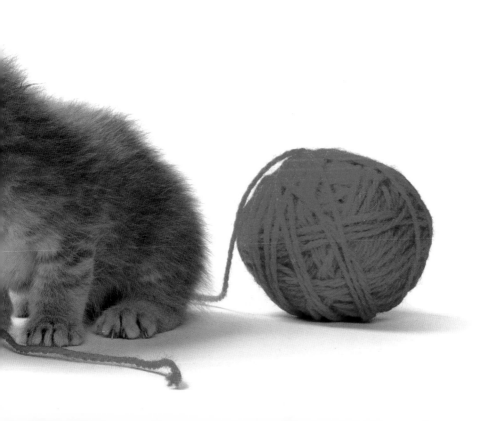

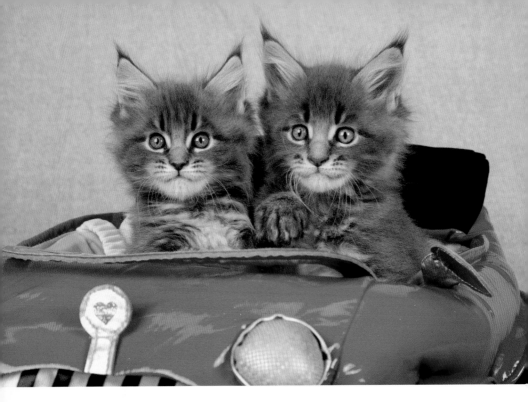

ABOVE: **BONNY AND CLIVE** plan their getaway.

RIGHT: **ANGEL AND SNOWBALL** dream sweet dreams of each other.

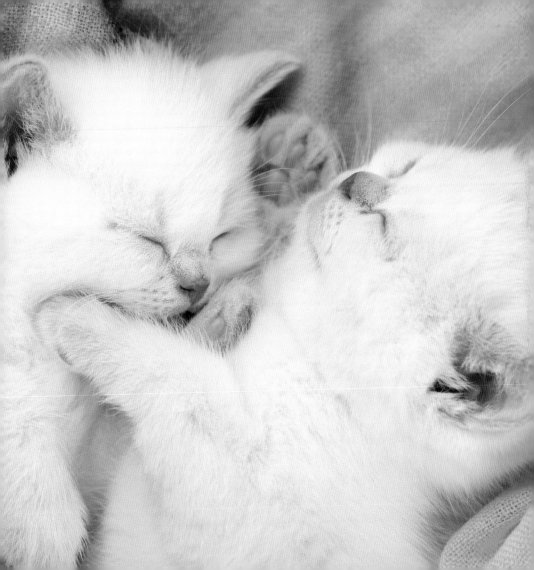

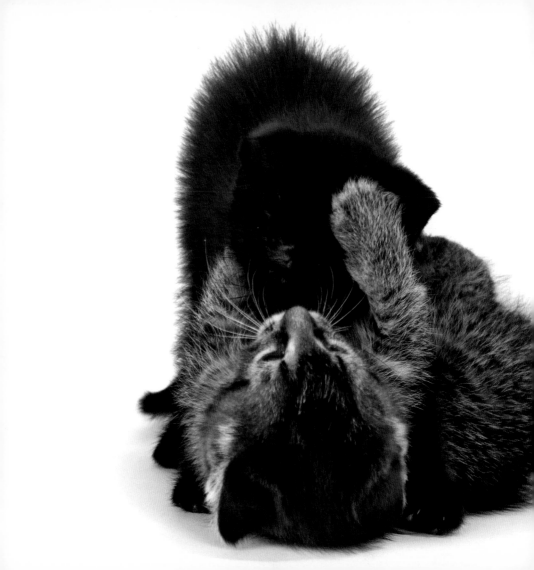

INKY AND HAZEL

are fifty shades of gray.

RIGHT: **FRED AND GINGER** break out into the Gangnam Style dance.

BELOW: **PRINCE AND PETULA** are pretty in pink.

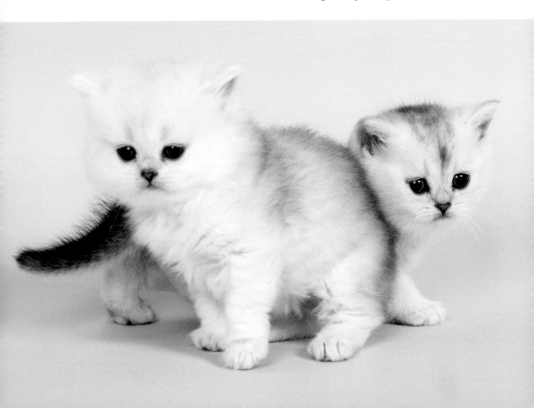

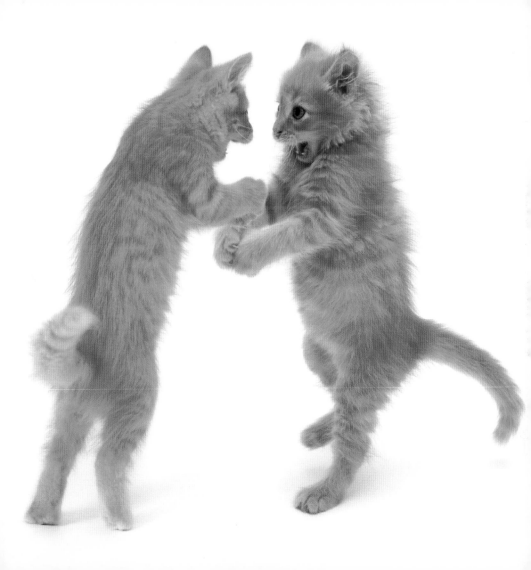

PUMPKIN AND MAX

are ready for their close-up.

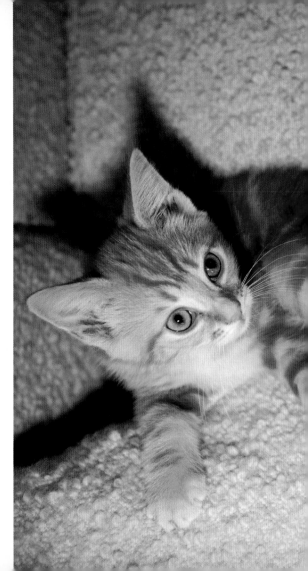

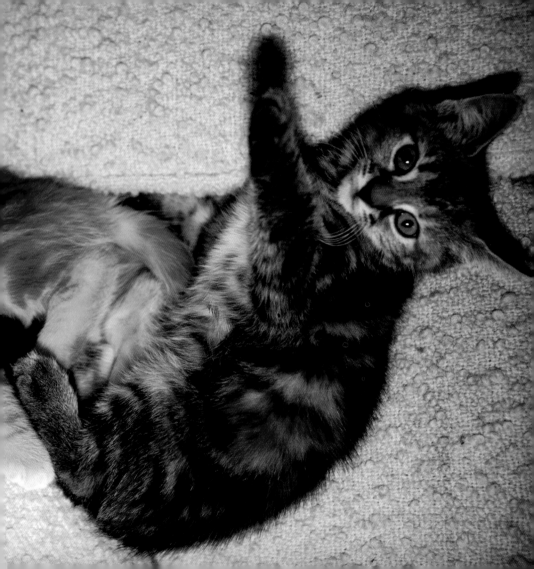

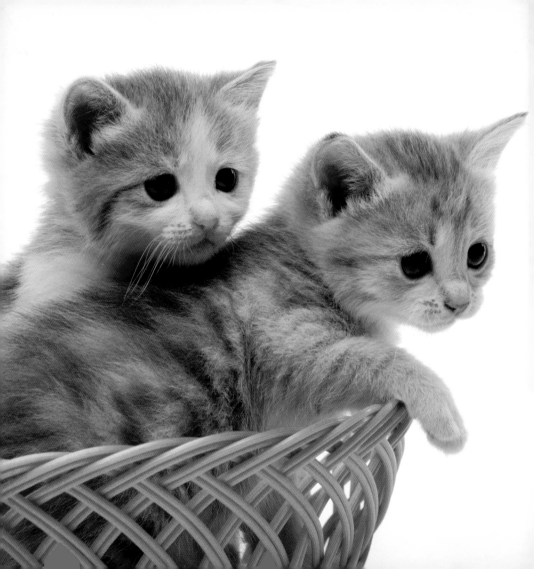

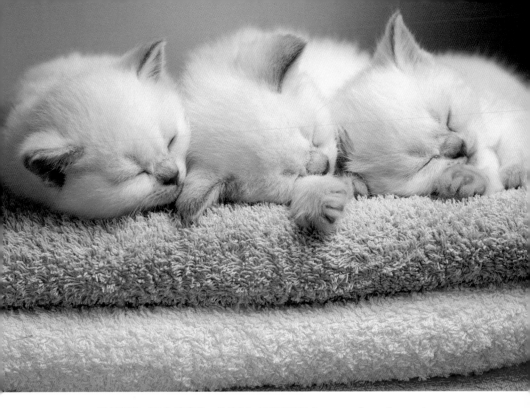

ABOVE: **BRIE, ROCCO, AND DIXIE** know that happiness is a warm fluffy towel to snuggle on.

LEFT: Without **KATE, LEO** would be a basket case.

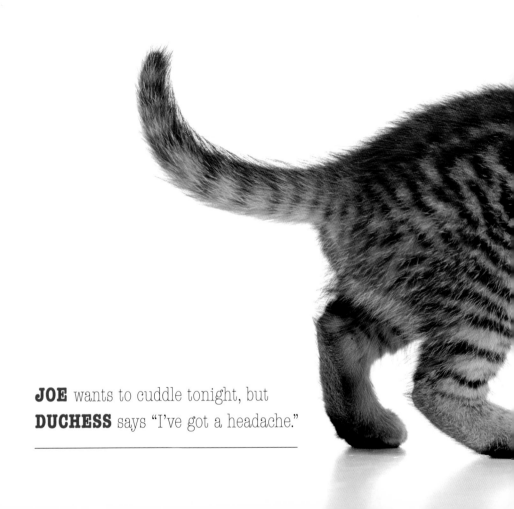

JOE wants to cuddle tonight, but
DUCHESS says "I've got a headache."

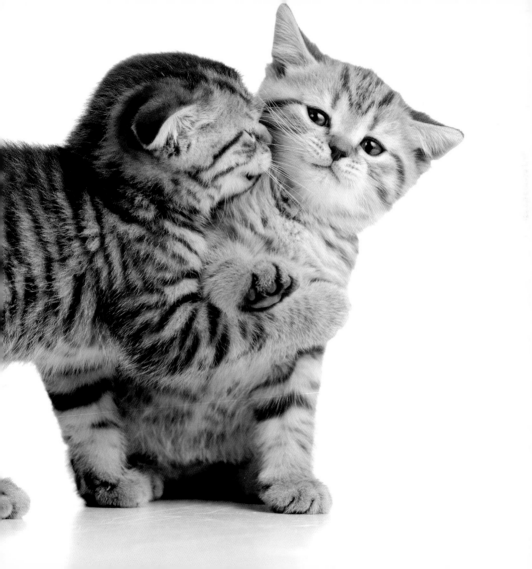

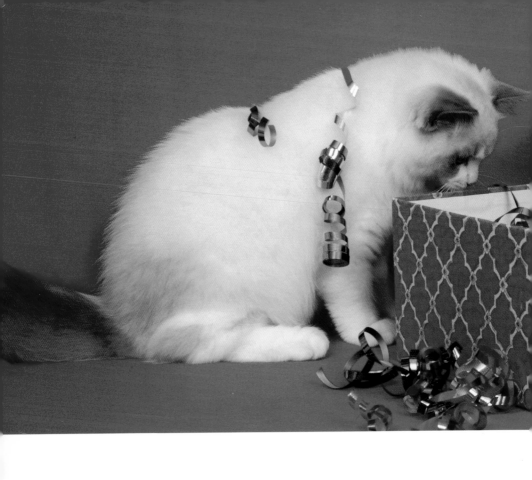

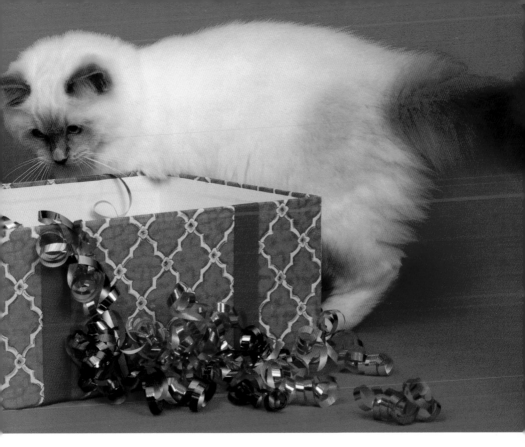

DOLLY and **ZEUS** know that the best presents come in fluffy packages.

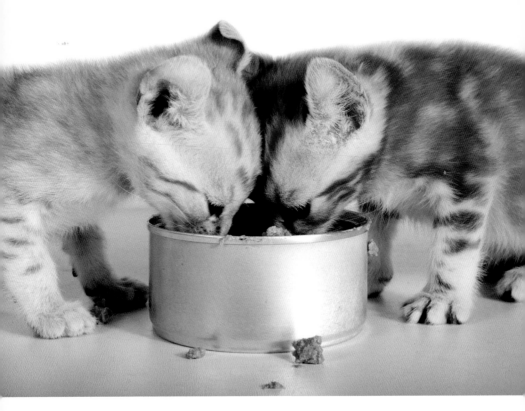

BAILEY says to **BEAUTY** . . . dinner at my place?

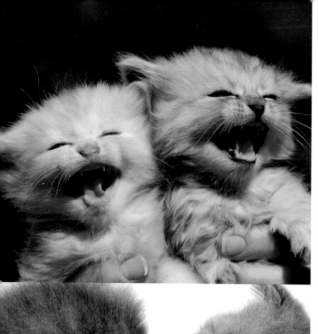

BELLA AND EDISON sing a song of love.

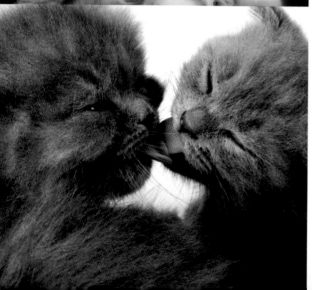

WHISKERS AND KIKI like to share a kiss.

Aristocats **PRINCESS AND WILLY**
contemplate their future together.

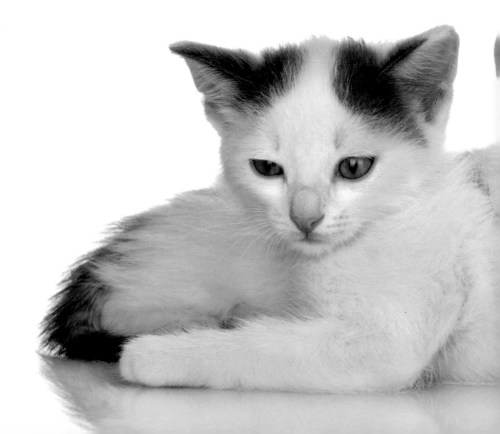

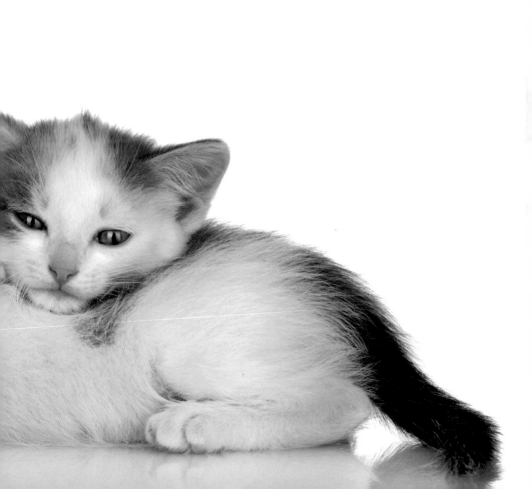

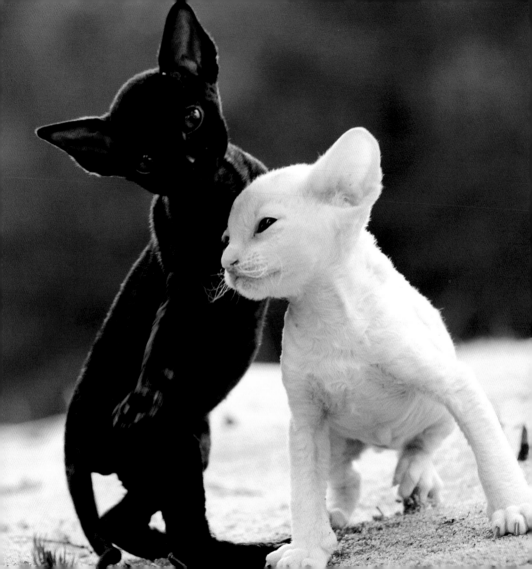

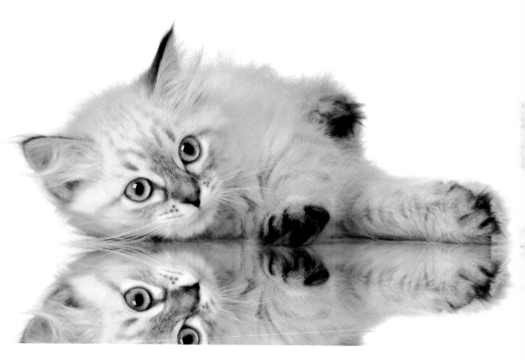

ABOVE: **NARCISSUS** loves his reflection.

LEFT: **DANTE AND CUPCAKE** like to take long walks on the beach.

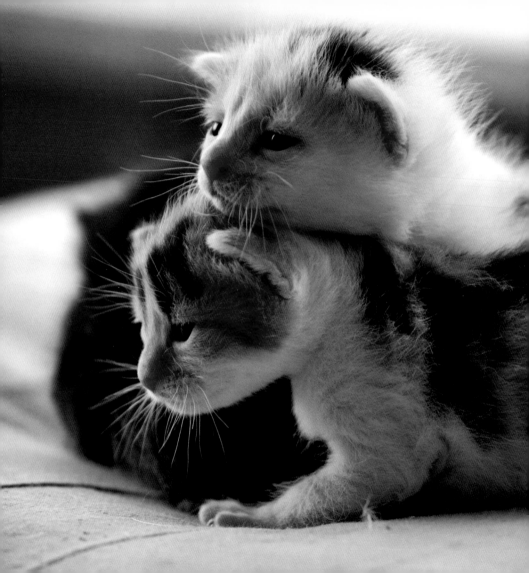

PINKY AND PATCHES

celebrate young love.

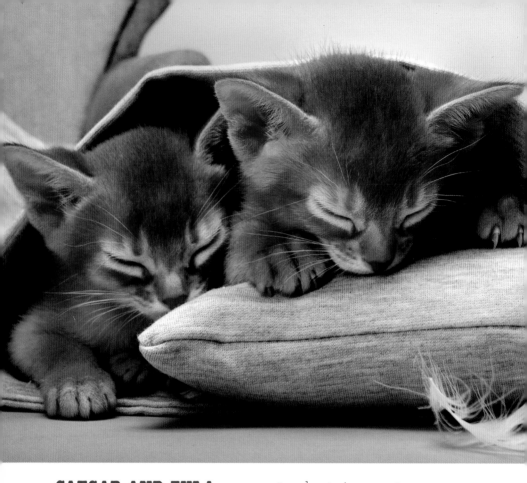

CAESAR AND ZULA are snug as bugs in a rug.

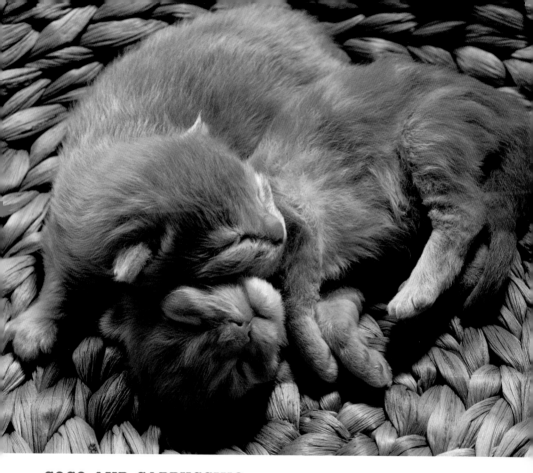

COCO AND CAPPUCCINO are interwoven.

SPIKE asks **SALLY** . . . may I have this dance?

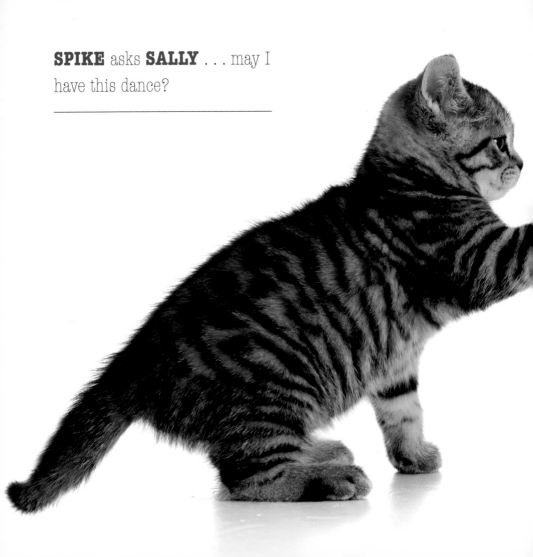

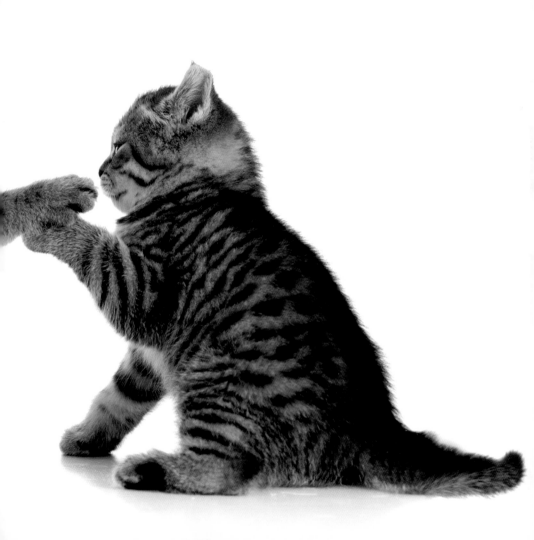

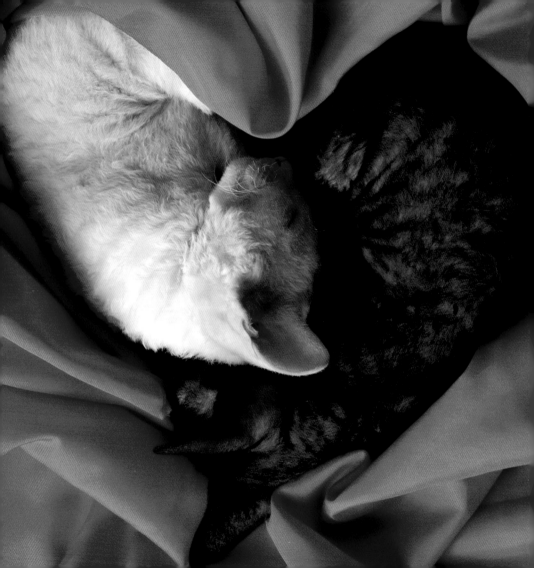

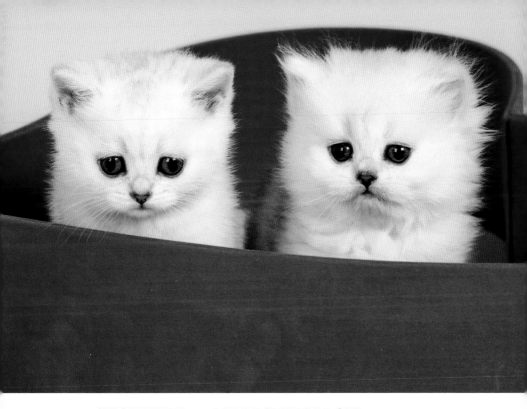

ABOVE: **SNOWBELL** and **MARSHMALLOW** are tiny, but all heart.

LEFT: **ROMEO** and **JULIET** are true sweet "hearts."

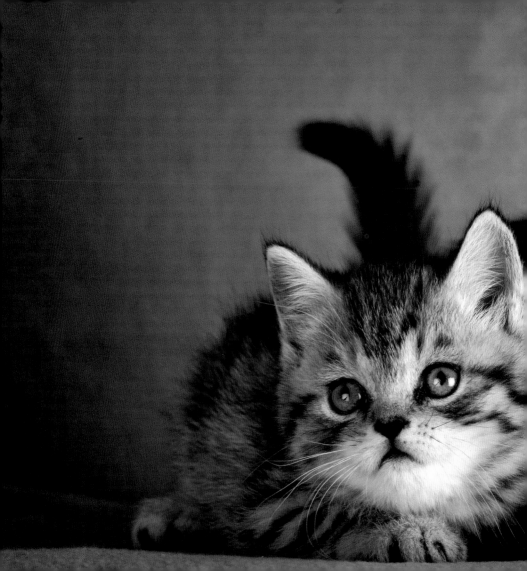

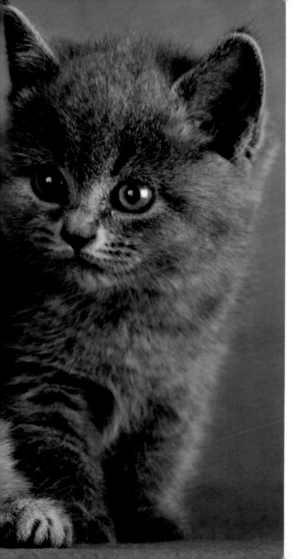

CLOUD loves **XENA**,
and **XENA** loves **CLOUD**.

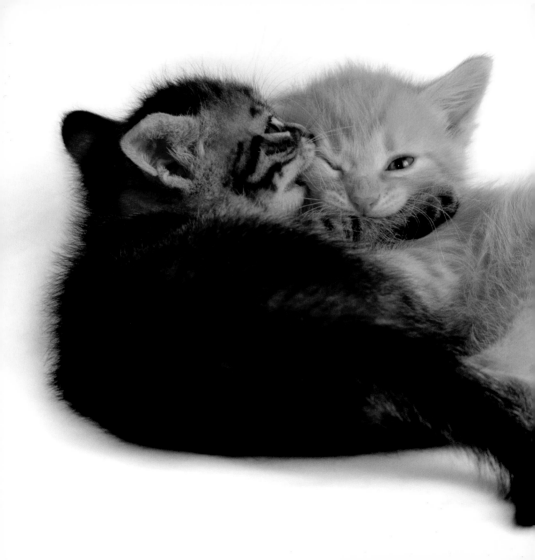

BARNABAS likes to give **PEACHES**
little love bites.

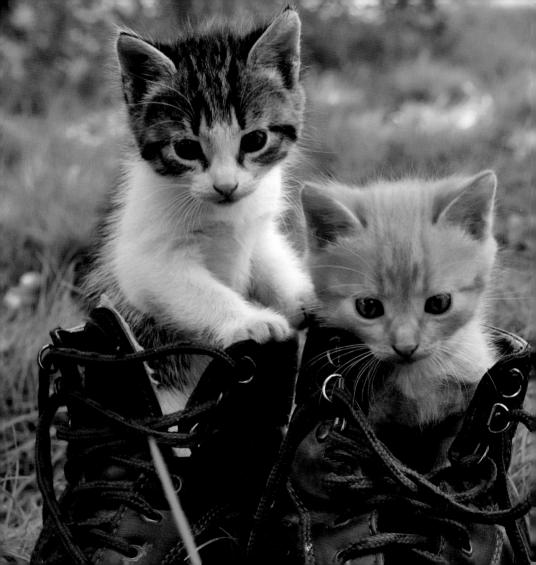

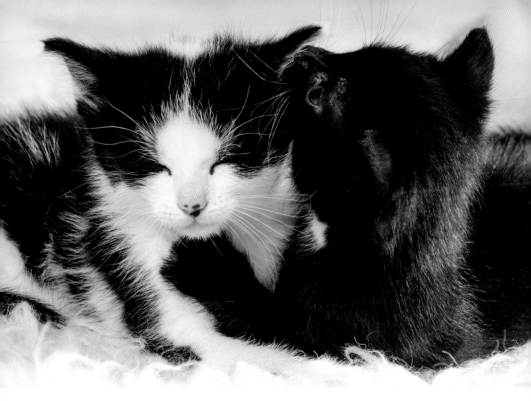

ABOVE: **STEVE** whispers sweet nothings into **MOLLY'S** ear.

LEFT: **SUGAR RAY** and **SUNFLOWER** are "sole" mates.

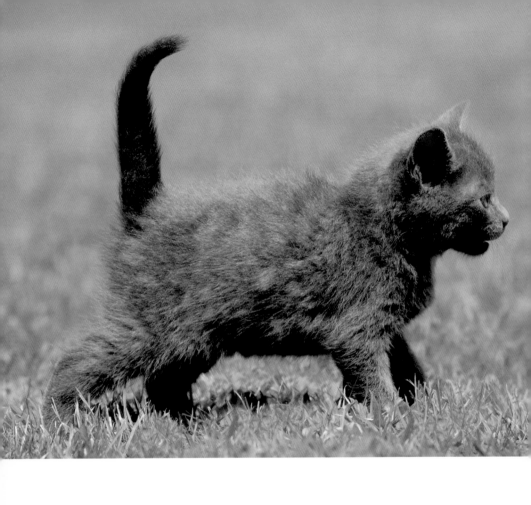

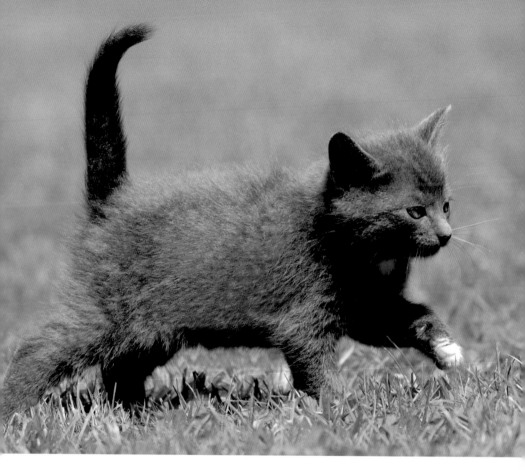

Where **STORMY** went, **CINDERELLA** followed.

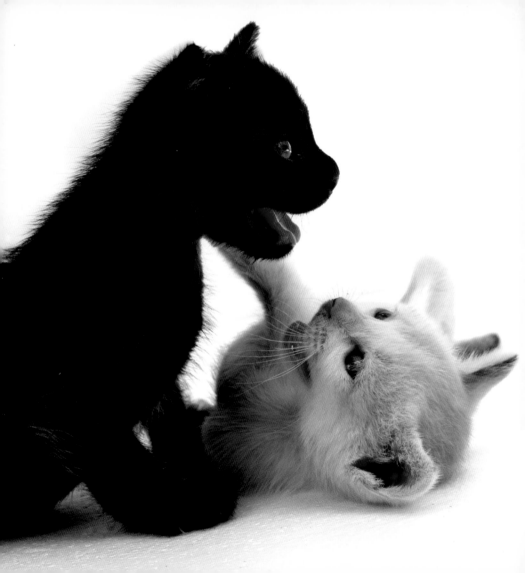

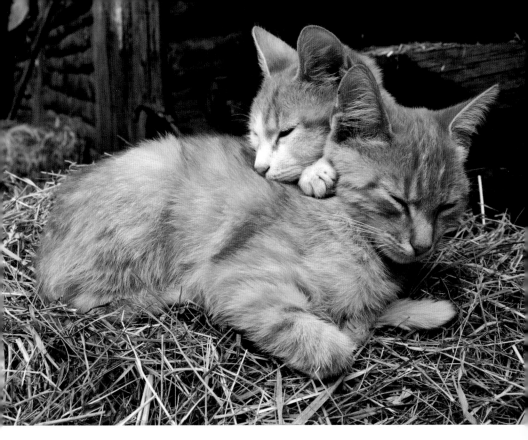

ABOVE: **WHISKY AND ELSIE** like a good cuddle in the hay.

LEFT: **LUNA** wants **BLACKJACK'S** undivided attention.

BUTTERCUP was the apple of **JOHNNY'S** eye.

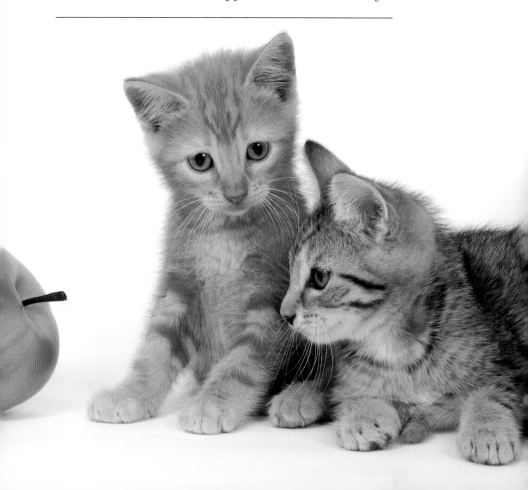

MAX assures **SAMANTHA** that she looks good from behind.

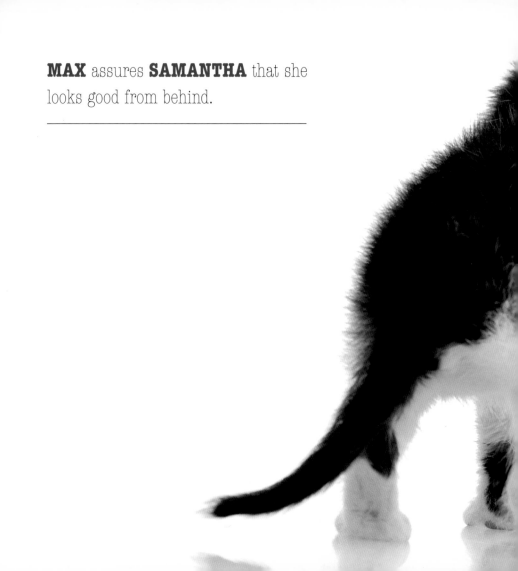

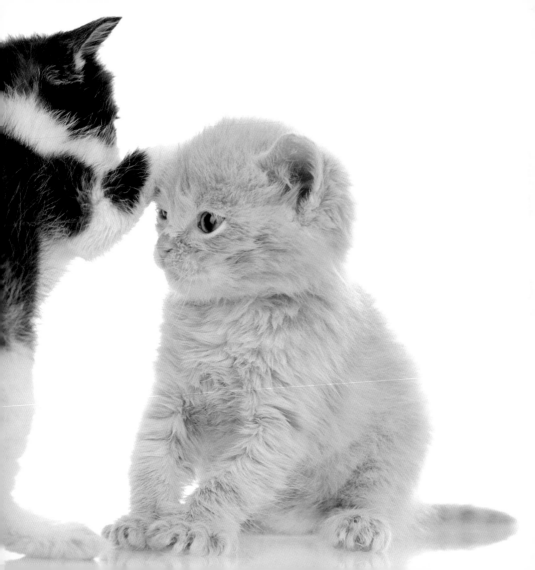

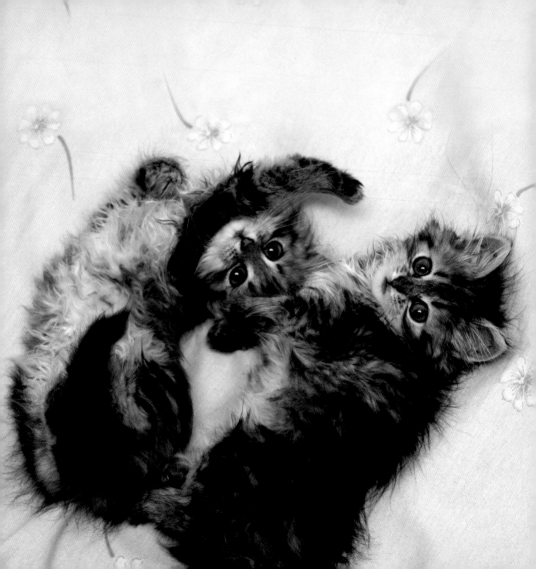

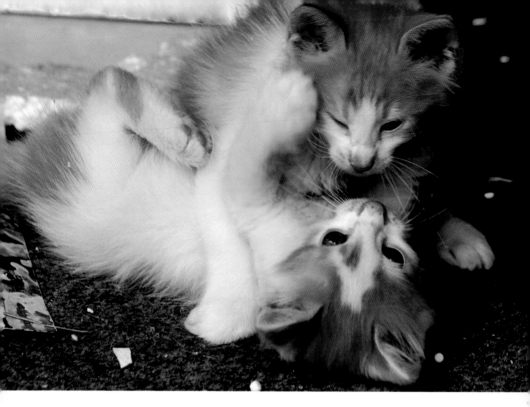

ABOVE: **SCARLET AND SIMBA** are a passionate pair . . . passion means every once in a while you break something.

LEFT: **SCRUFFY AND LUCY** do their morning yoga together.

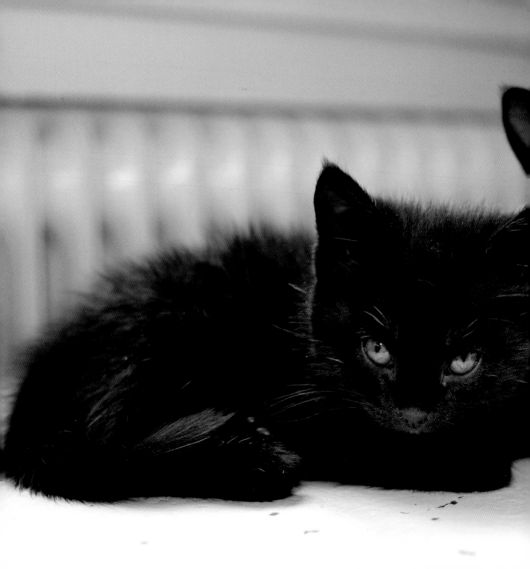

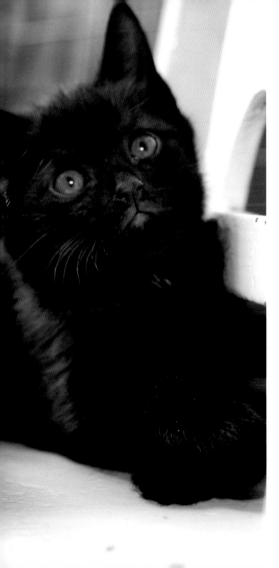

ABRA AND DUSTY

"paws" for a little snuggle.

RORY AND RUSTY take a walk on the wild side.

MOBY loves **MANGO'S** beautiful baby blues.

SHEBA AND APOLLO are never more than arm's length from each other.

GRAYCIE brightens **GANDALPH'S** gray days.

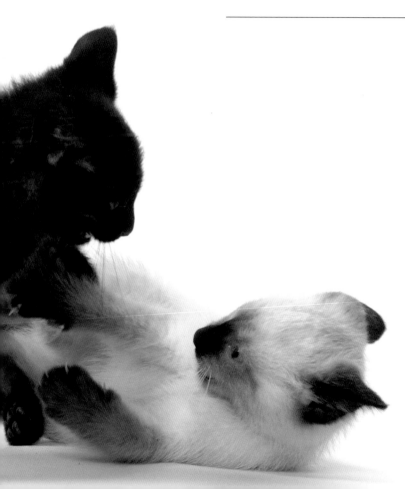

MIDNIGHT tickles **CLEO'S** fancy.

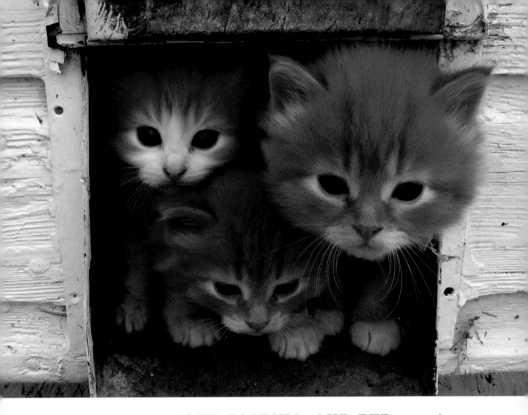

ABOVE: Together, **FOXY, PAPRIKA, AND RED** can take on anything.

RIGHT: **SNOWFLAKE AND SARGE** are inseparable.

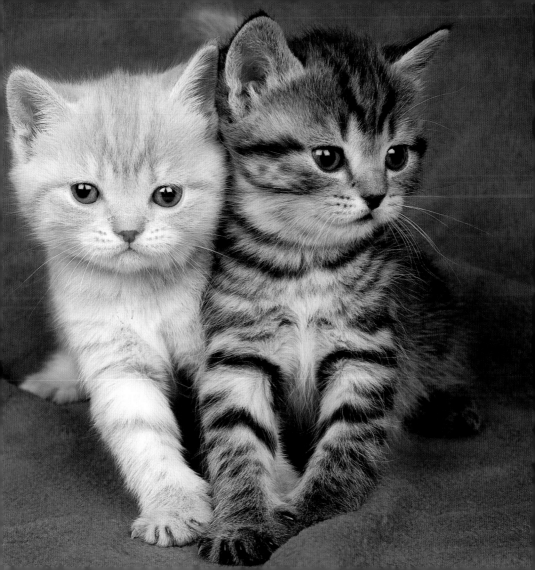

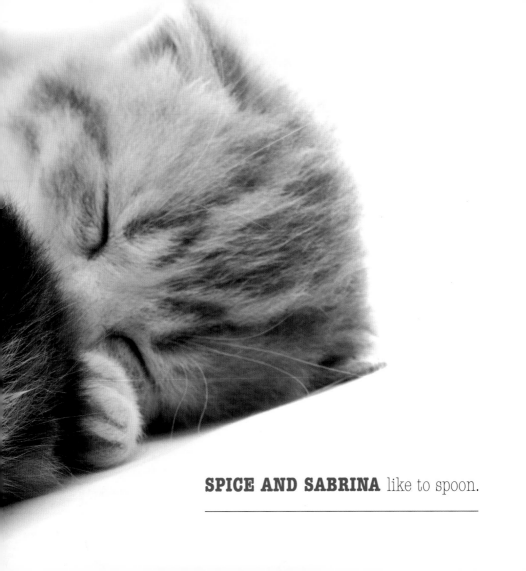

SPICE AND SABRINA like to spoon.

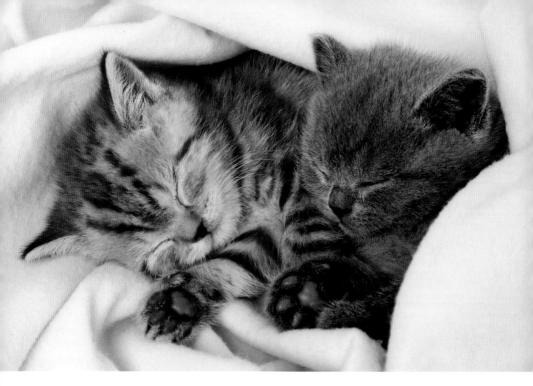

WHISKERS AND MUFFIN like to hit the snooze button.

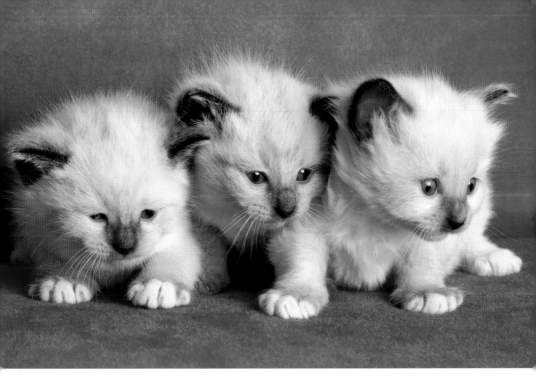

SLEEPY, SNOW WHITE, AND PRINCE look regal on red.

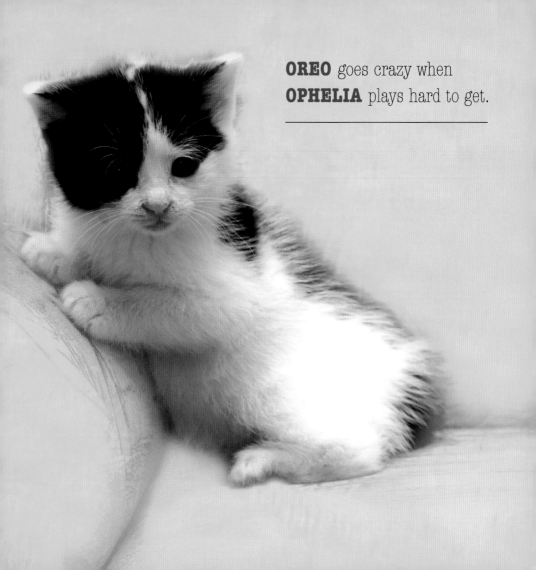

OREO goes crazy when
OPHELIA plays hard to get.

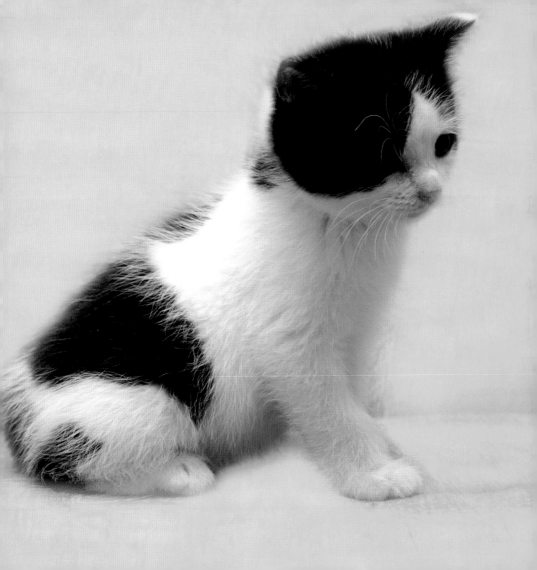

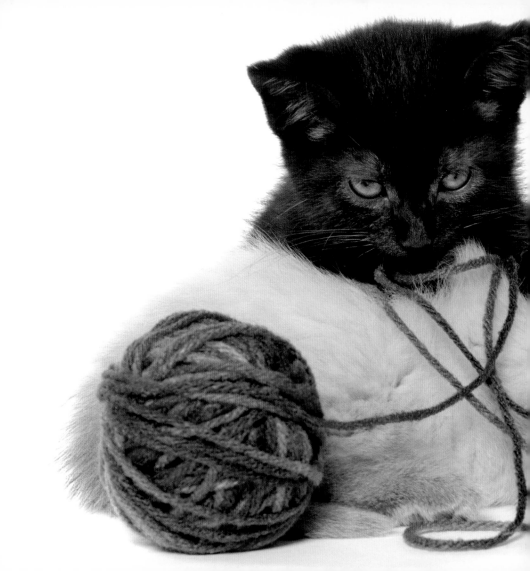

KIKI pulls at **MOCHA'S** heartstrings.

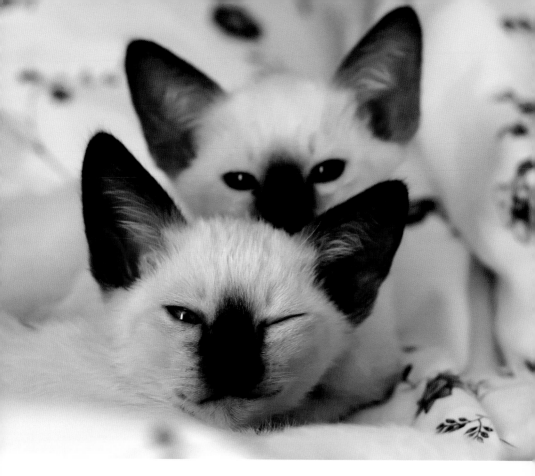

WINKY AND LEIA like lounging.

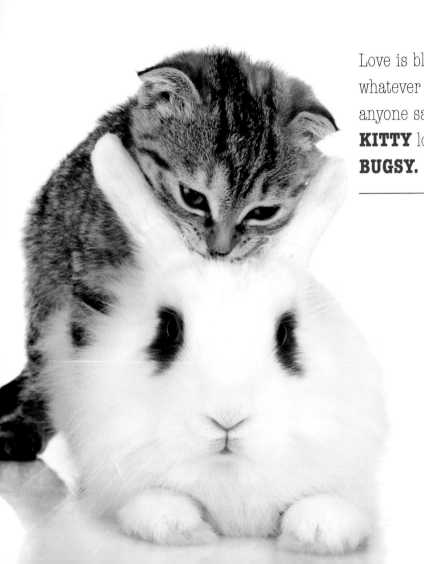

Love is blind . . . whatever else anyone says, **KITTY** loves **BUGSY.**

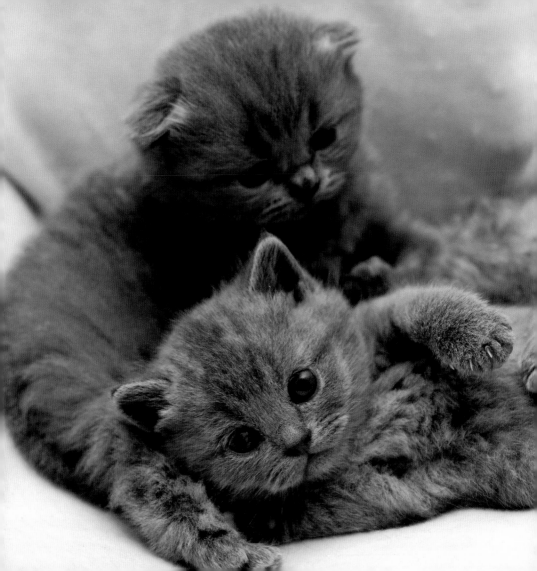

COUNT, MINA, AND QUINCY love hanging out and killing time.

DR. SOCKS AND MISTY dream a little dream of each other.

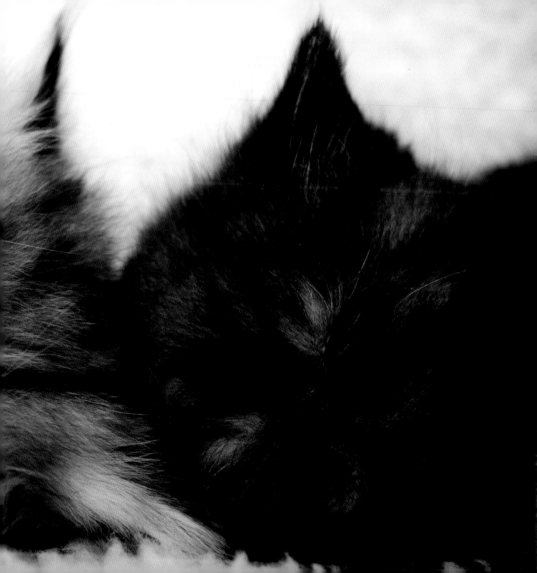

PHOTO CREDITS